PUGS

ON RUGS

PUGS
ON RUGS

JACK RUSSELL

THOMAS DUNNE BOOKS
ST. MARTIN'S GRIFFIN ✿ NEW YORK

THOMAS DUNNE BOOKS
An imprint of St. Martin's Griffin

For information, address St. Martin's Press, 175 Fifth Avenue,
New York, N.Y. 10010.

www.thomasdunnebooks.com
www.stmartins.com

Library of Congress Cataloging-in-Publication Data
on file at the Library of Congress

ISBN: 978-1-250-11187-6 (hardcover)
ISBN: 978-1-250-11188-3 (e-book)

Editorial and design by
Amber Books Ltd
74–77 White Lion Street
London N1 9PF
United Kingdom
www.amberbooks.co.uk

Project Editor: Sarah Uttridge
Designer: Rick Fawcett
Picture Research: Terry Forshaw

Printed in China

First U.S. Edition: February 2017
10 9 8 7 6 5 4 3 2 1

PICTURE CREDITS
Alamy: 74 (A. T. Willett)
Depositphotos: 8 (Dogford Studios), 10 (Jackson Jesse), 12 (Eugen Wais), 14 (Ulkan), 16 (Feedough), 20 (Eric Isselée), 22 (Valik1990), 24 (Vladimir Engel), 26 (Eugen Wais), 28 (Eric Isselée), 30 (Willeecole), 32 (Eric Isselée), 34 (Willeecole), 38 (Vyacheslav Karlov), 42 (Damedeeso), 44 (Vladimir Engel), 46 (Kevin McKeever), 52 (Ulkan), 54 (Damedeeso), 56 (Di-Studio), 58 (Ulkan), 60 (Natulrich), 62 (Ifong), 64 (Vladimir Engel), 66 (Aquaplane6280), 68 (Ulkan), 70 (Vladimir Engel), 72 (Willeecole), 74 (Absolutimages), 76 (Eugen Wais), 78 (Natalia Ulrikh), 80 (Jackson Jesse), 82 (Eriklam), 86 (Viorel Sima), 88 (Eugen Wais), 90 (Willeecole), 92 (Eric Isselée), 94 (Vyacheslav Karlov), 96 (Damedeeso)
IngramImage: 6, 18 (Emanuelle Bonzami), 36, 40, 48, 50, 84
Rugs on the following pages courtesy of **The Nazmiyal Collection**: 6, 8, 10, 12, 14, 16, 18, 20, 22, 24, 26, 28, 34, 40, 42, 44, 50, 52, 54, 68, 70, 78, 80, 84, 86
Rugs on the following pages courtesy of **Richard Rothstein & Co.**: 30, 32, 36, 38, 46, 48, 56, 58, 60, 62, 64, 66, 72, 76, 82, 88, 90, 92, 94

Contents

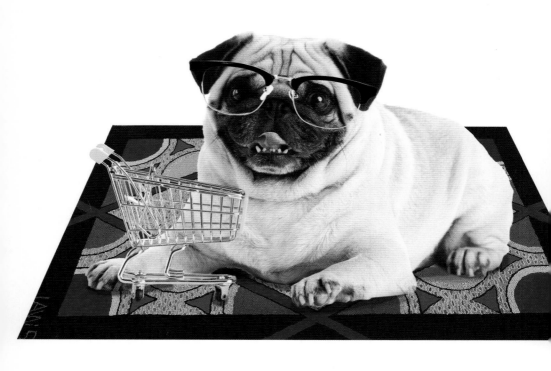

Try Aisle K-9

"Funny how different things look with your glasses on. I'd always thought shopping carts were much bigger than me."

Rug Fact: An art deco, American hooked rug from about 1920.

Pug Fact: In 17th-century England, "pug" was the nickname for both a dog and a monkey.

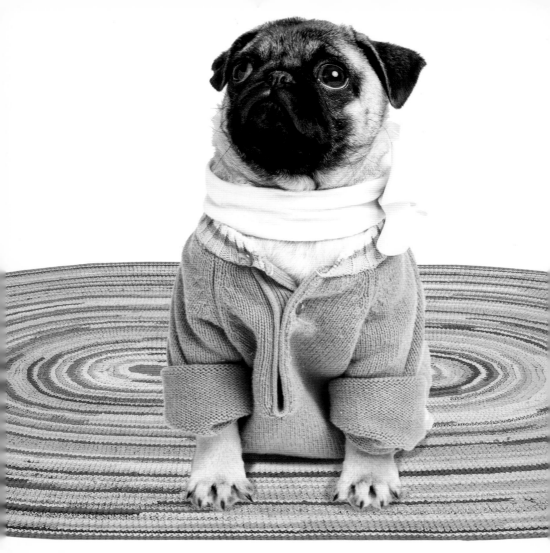

Puggy Pinkmentation

"I know what you're thinking: the pink clashes with the rug, doesn't it?"

Rug Fact: An American hooked rug from around 1900. Originating in the northeastern United States and Canada, hooked rugs were first made from scraps of material and even burlap sacks.

Pug Fact: A pug can run from 3 to 5 miles per hour.

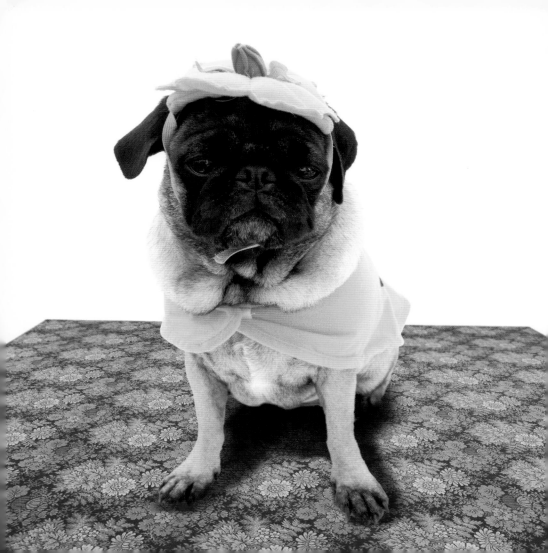

Pugkin Pie

"Pugs aren't just for Christmas. They're for Halloween, too."

Rug Fact: An American ingrain rug from around 1920. Ingrains are flat, reversible rugs with no pile.

Pug Fact: Pugs sleep for about 14 hours a day.

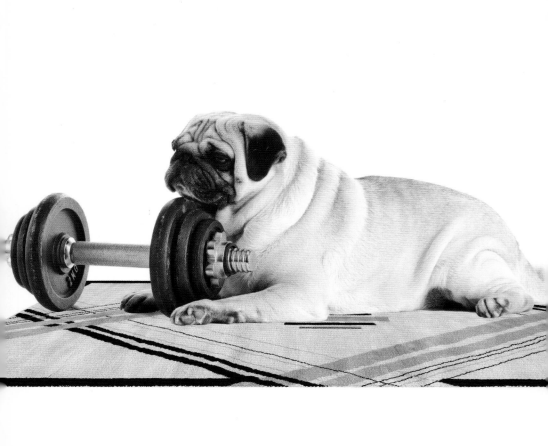

Weight Watching

"The wheels seem to have come off your train set. Come to think of it, aren't you a bit old to have toy trains?"

Rug Fact: An early 20th-century, French, art deco rug, a style characterized by its geometric patterns.

Pug Fact: Napoleon Bonaparte's wife, Josephine, had a pug called Fortune. She used it to send secret messages to her husband. Unfortunately, fortune didn't favor Fortune, and, one day, it had a fatal encounter with the chef's bulldog.

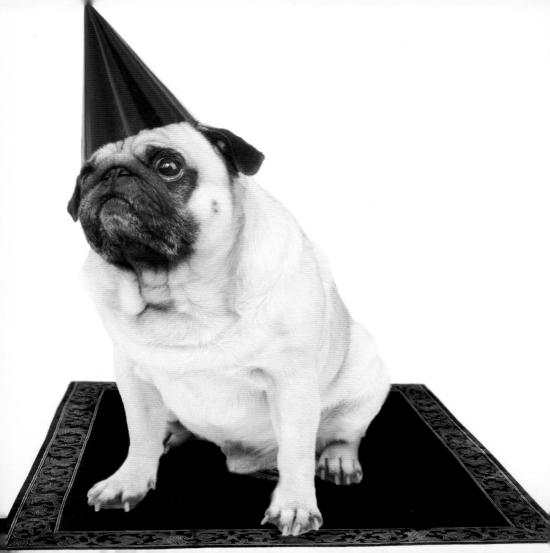

Party Poocher

"Honestly, I'm as happy as a dog with two tails. I just don't yap on about it."

Rug Fact: A Chinese art deco rug from the early 20th century.

Pug Fact: During the Tang Dynasty in China (618–907 CE), pugs were sent as state gifts to Japan and Korea.

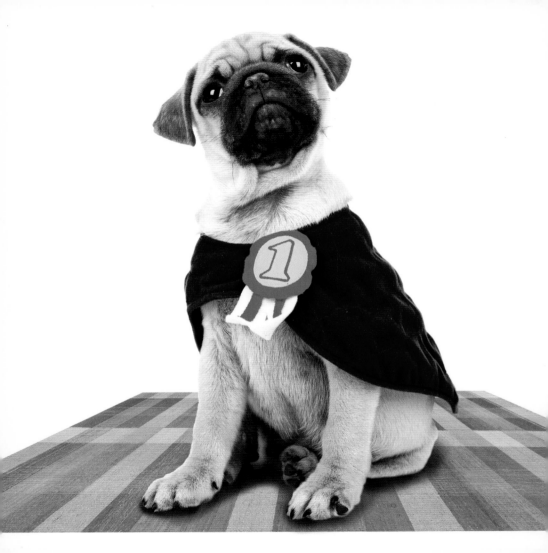

A Bird? A Plane? No, Superpug!

"So you think Batman, Spider-Man, and Ant-Man are perfectly reasonable, but a superhero pug is weird?"

Rug Fact: A 1920s American rag rug. Originally, many were made from scraps of fabric, but rag rugs have become admired examples of American design.

Pug Fact: Pugs were imported into the United States in the 19th century. The American Kennel Club in 1885 first recognized pugs as a distinct breed.

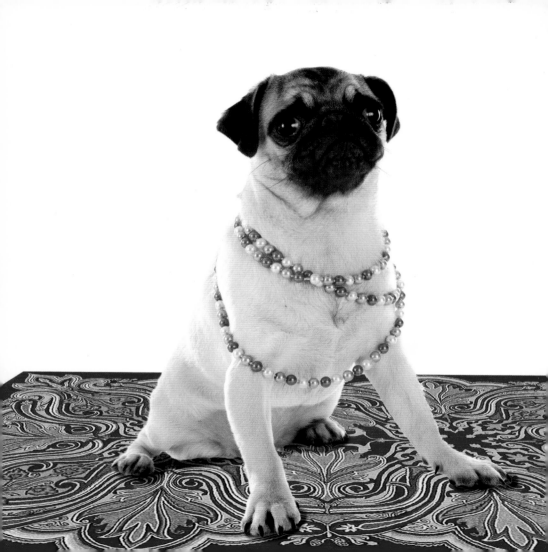

Mother of Pearl!

"Diamonds are a girl's best friend, but *someone* seems to think cheap beads are a pug's. You know, I fear for their rug."

Rug Fact: The flowing lines and organic nature of an American, hooked, art nouveau rug from the 1920s.

Pug Fact: *Zhu,* meaning "Pearl," is a popular name for a pug in China.

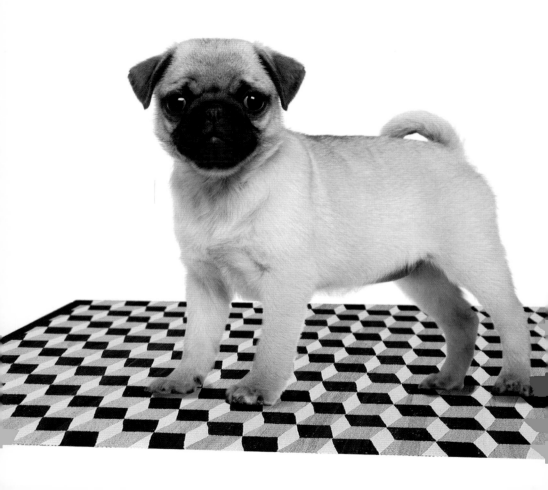

Un*yappy* Pug

"This looks more like stepping-stones than a nice comfy rug!"

Rug Fact: A striking, mid-20th century, Navajo Kilim rug that uses three colors and three rectangular figures to create the impression of a cube. Repeated, the design forms a stack.

Pug Fact: Pugs are not very good swimmers because of their short and stout body.

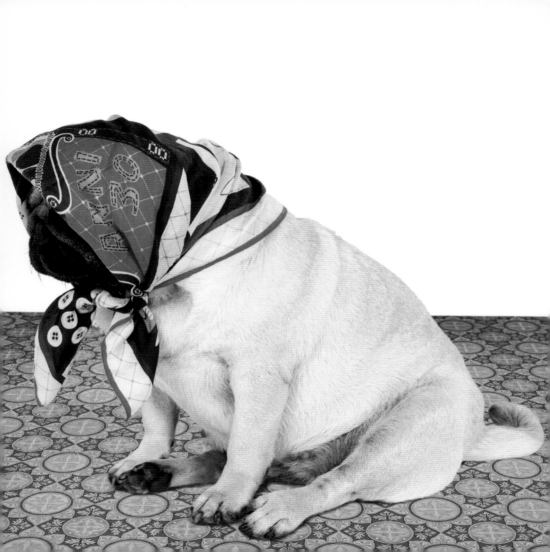

The Queen's Pug

"If I keep this scarf on, Her Royal Highness won't know I'm not a corgi."

Rug Fact: An English needlepoint rug from the late 19th century. With its medallions and fleur-de-lis in each petal, the neo-medieval design shows the influence of the English Arts and Craft Movement.

Pug Fact: Queen Victoria bred pugs, encouraging their popularity in 19th-century Britain.

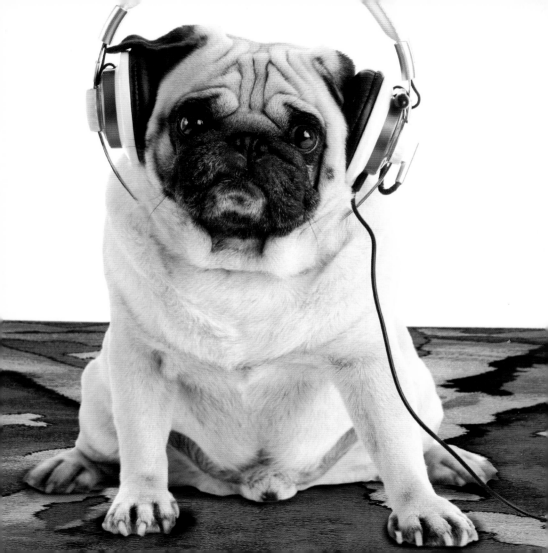

Pug Daddy

"What do you think I'm listening to: Snoop Dog or Kate Bush's *Hounds of Love?*"

Rug Fact: A Swedish *rya* from the middle of the 20th century. Rya, which simply means "rug" in Swedish, has a long, dense pile. They were inspired by Turkish bedding rugs.

Pug Fact: Pugs catch colds easily. They are quickly stressed by hot or cold weather because they cannot regulate their body temperature very well.

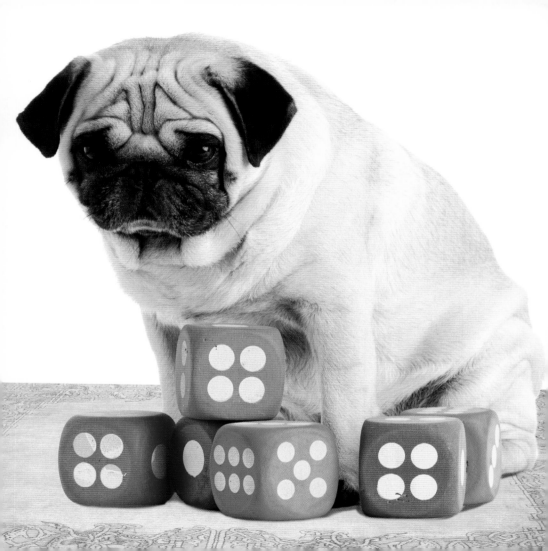

Dicing with Dogs

"Great, now even the rug's got worms. Just look at that border."

Rug Fact: An English William Morris rug from the turn of the 20th century. The design consists of a tangle of Celtic knots featuring serpents' heads.

Pug Fact: Pugs are not good gamblers.

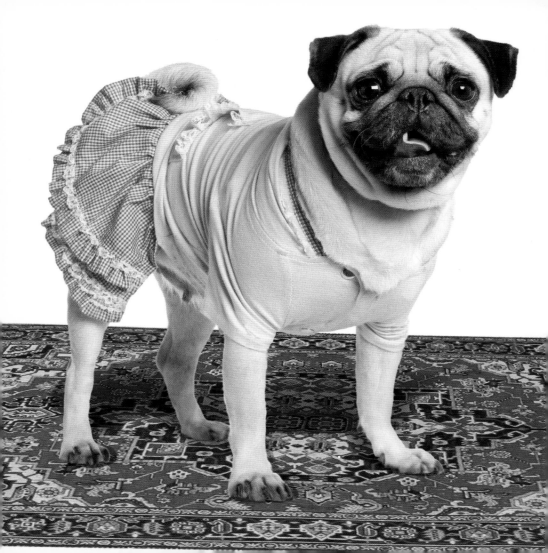

On the Catwalk

"Well, Huckleberry Finn once dressed as a girl, and he's a national hero."

Rug Fact: It may look Persian in style, but this is an American chenille rug. *Chenille* is the French word for "caterpillar," as the yarn resembles caterpillar fur.

Pug Fact: Pugs were dressed in colorful pantaloons when traveling in the carriages of Italian aristocrats.

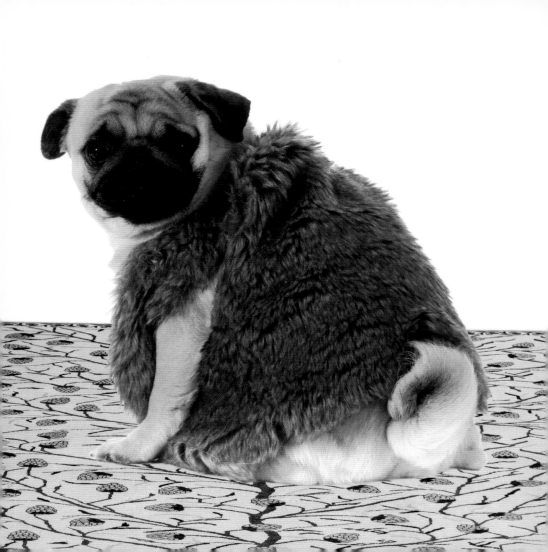

Shaggy Dog Story

"I get the itchy feeling that this coat wasn't the only thing I picked up at the flea market."

Rug Fact: A hand-knotted Karabagh rug from the southern Caucasus. Karabagh carpets often have geometrical patterns, but they can also be inspired by organic and floral motifs from Iran. This one shows strawberries on a tree of life.

Pug Fact: It is believed that the pug was introduced to Europe from Asia by the Dutch East India Company.

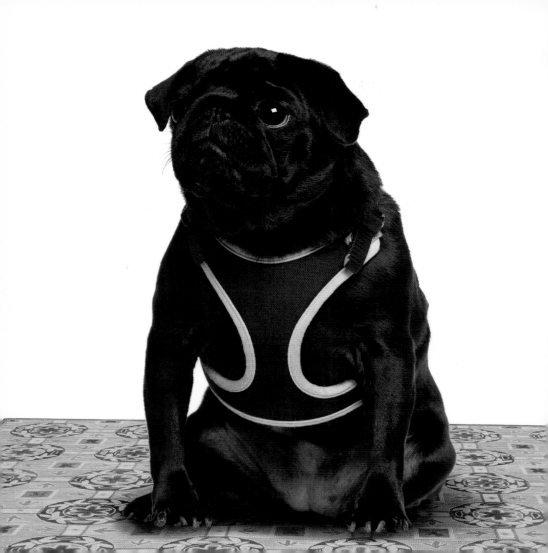

Pugnacious

"Well, you'd look grumpy, too, if someone had put your sports bra on backward."

Rug Fact: A hand-hooked, American rug with a country-cottage ceiling design. Originating in the 1840s, these functional, coarse rugs were first made out of necessity. As interest in American folk art has grown, they have become sought after.

Pug Fact: The aristocrat Lady Anna Brassey is credited with making black pugs fashionable in Britain after she brought some back from China in 1886.

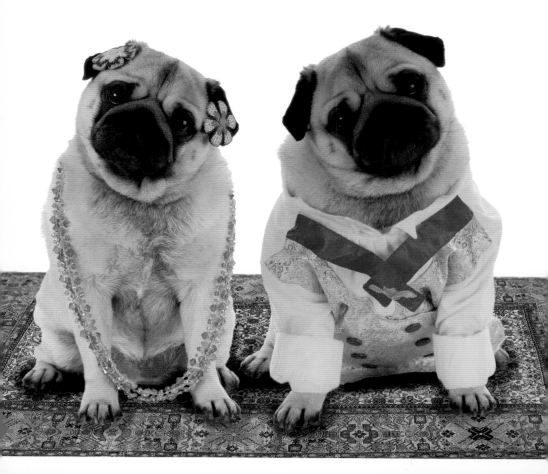

Lapdogs of Luxury

The lavish wedding of Prince Pug and Princess Puggette. They're cousins.

Rug Fact: Made in Pakistan, this rug features the detailed floral motifs and precise Herati pattern characteristic of the Sultanabad, now Arak, region.

Pug Fact: It has been claimed that the pug became the official dog of the House of Orange in the Netherlands in the 16th century after William the Silent's pug Pompey saved his life by alerting him that assassins were approaching.

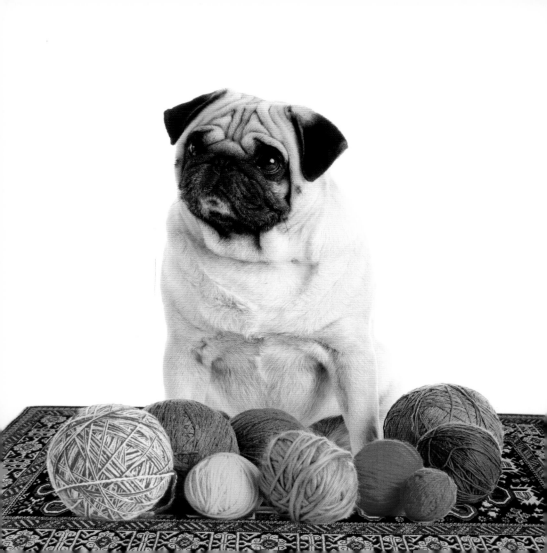

In Stitches

"You want me to turn the yarn into a rug like this? OK, can someone get me Rumpelstiltskin's number?"

Rug Fact: A Perpedil rug from Perpedil in the Dagestan region of the Caucasus. Perpedil rugs are characterized by their use of ram's horn motifs.

Pug Fact: Pugs come in four colors: apricot, fawn, black, and, more uncommonly, silver.

Smug Pugs

"Stare at this rug long enough, and *you'd* see double."

Rug Fact: With fine local wool, master weavers, and excellent designs, the Persian city of Kerman built a reputation for its carpets by the 18th century. Some people consider Kerman carpets to be the best.

Pug Fact: Pug puppies are called "puglets."

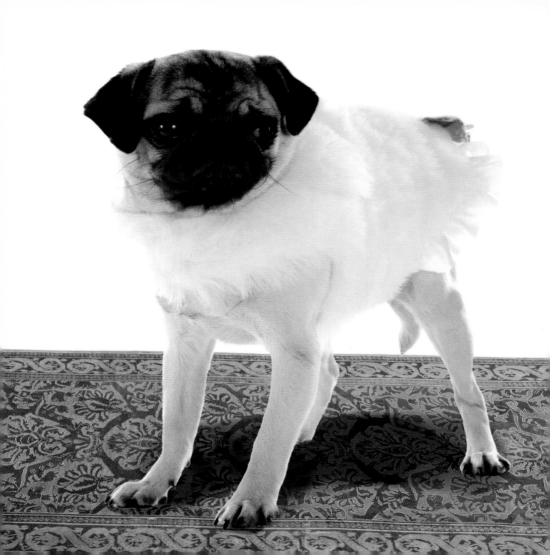

Pug de Deux

"I'm not a diva, I'm a prima ballerina."

Rug Fact: A Spanish Alcaraz rug from the latter part of the 16th century. After Christians retook the area now known as Spain and Portugal from the Moors at the end of the 15th century, Spanish rugmakers developed a more European style. In this rug, you can see acanthus leaves in the center and dragon motifs around the border.

Pug Fact: Although there have been all-male performances of the ballet *Swan Lake*, there has yet to be an all-pug version.

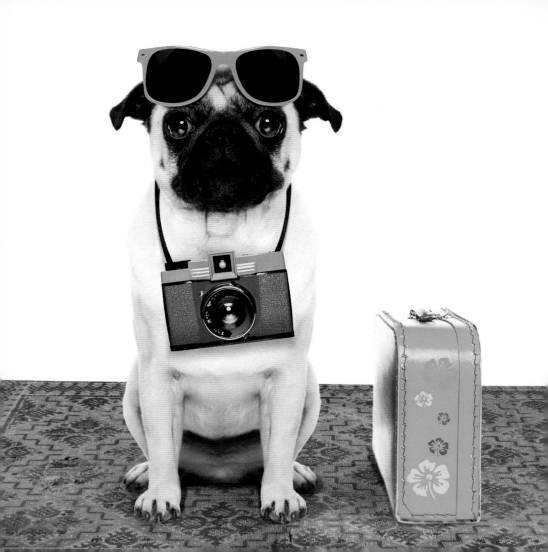

Won't Travel by Greyhound

"This is a flying carpet, right? Because I'm trying to get to Chihuahua."

Rug Fact: A Portuguese Alpujarra rug from the beginning of the 20th century. It features a popular, Portuguese pomegranate symbol.

Pug Fact: Are you single and love pugs? There are now dating events where you can meet other pug lovers. Even if the date doesn't work out, at least you get to meet some lovely pugs.

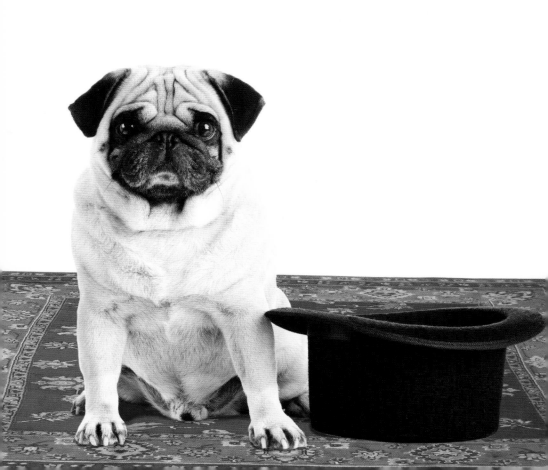

Take a Bow-Wow

"I'm actually a human statue posing as a pug. Donations in the hat, please."

Rug Fact: Although this rug has a Persian design, it was made in Donegal, in Ireland, around 1900.

Pug Fact: In Italy, pugs are called "Carlino," after the 18th-century actor Carlo Bertinazzi, who was best known for playing the character Harlequin wearing a black, puglike mask.

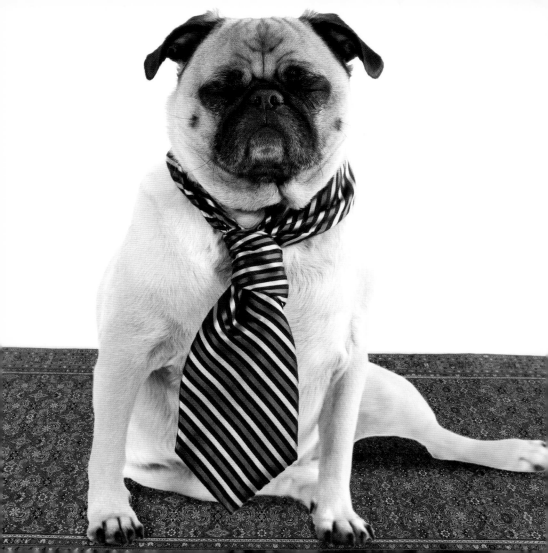

Dog-Tired at the Office

"I hate my job, but if you hang in there long enough, they give you a rug like this."

Rug Fact: An antique Persian Feraghan with a characteristic Herati floral pattern.

Pug Fact: For pugs that understand Latin, the breed is often described as *multum in parvo,* or "much in little."

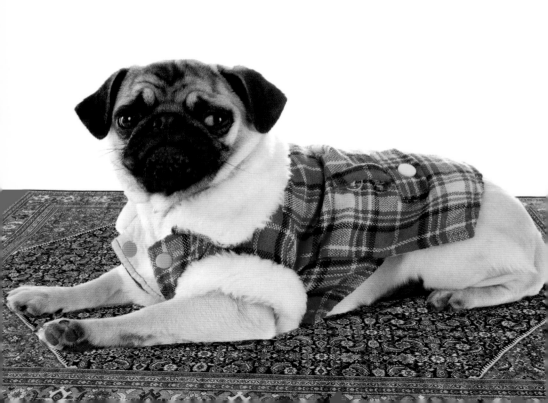

Canine Chic

"Never mind the Tartan pattern, the collar and cuffs are virtually a *ruff*, don't you think?"

Rug Fact: A Persian Mahal. Mahal rugs are durable, knotted, and they often have a centrally placed medallion and a distinct border.

Pug Fact: In 1740, a secret Masonic society called The Order of the Pug (*Mopsorden*) was formed in Germany. They chose pugs as their symbol because pugs are known for their loyalty and trustworthiness.

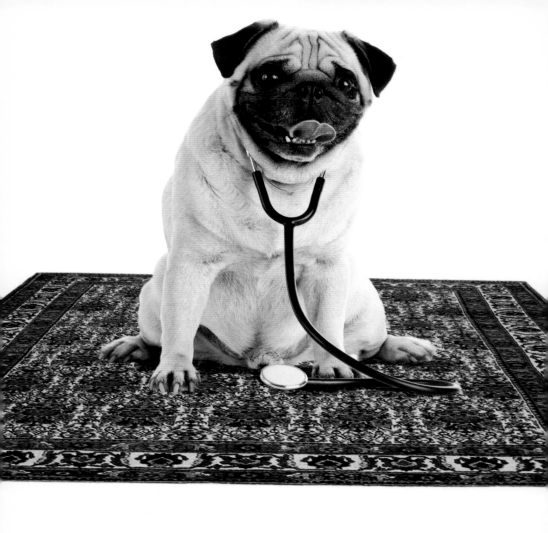

Dogtor's Orders

"Wherever I put my tongue in my mouth, I still can't say 'stethoscope'."

Rug Fact: A Persian Abadeh rug from the early 20th century. More typical examples have a hexagon at the center.

Pug Fact: Pugs are brachycephalic, meaning that their heads are wide but short, giving them that smashed-face look.

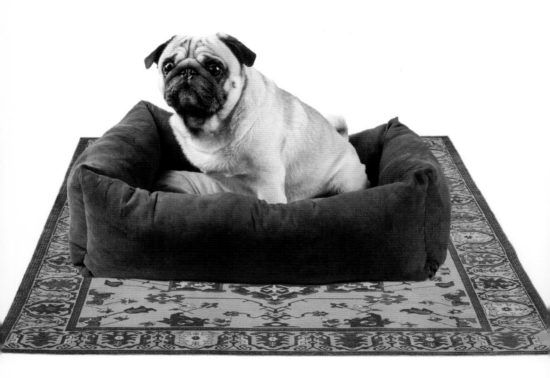

Pugolstery

"I know that as soon as I get comfy, they're gonna pull the rug out from under me."

Rug Fact: Known for their silky wool, Oushak rugs from Anatolia in Turkey often feature star and medallion patterns.

Pug Fact: The pug has ancestral ties to the Pekingese and perhaps the Shih Tzu.

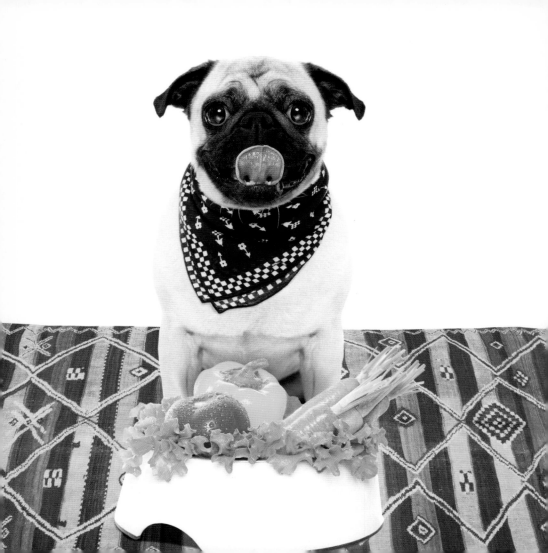

Dog's Dinner

"I must say I preferred the 'he eats what we eat' approach they had before they went all healthy."

Rug Fact: Made in Morocco around 1950, this Kilim rug features ancient protection symbols. Kilims are flat-woven rugs with a thin, supple structure.

Pug Fact: At 4 inches tall and weighing just 1 pound, 4 ounces, a pug called Pip, who lives in Dudley, West Midlands, UK, was considered to be the world's smallest pug in 2015. Despite her size, she is healthy, though she does prefer traveling in her owner's purse when it comes to long walks.

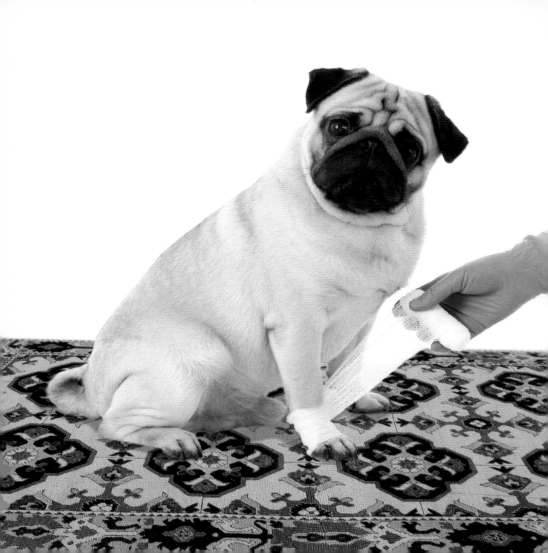

Paw Pug

"Sometimes, the bite is worse than the bark."

Rug Fact: A typically abstract design on an antique Karapinar rug from southern Turkey.

Pug Fact: Queen Victoria banned the cropping of pugs' ears in Britain.

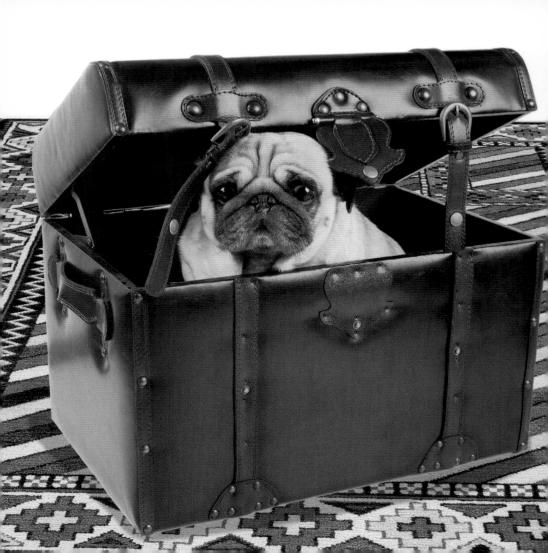

Pug Out, Starboard Home

"I bet the Shih Tzu gets carried in a purse."

Rug Fact: A Caucasian Gendje prayer rug. These rugs usually have shapes on the stripes, but these are plain.

Pug Fact: Pugs and beagles have been crossbred since at least the 1980s, creating "puggles."

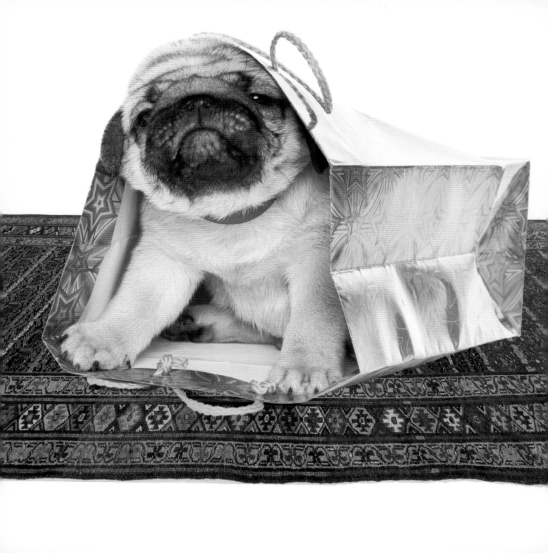

Doggy Bag

"I'm not just in a bag; it's bagism. You know, like John and Yoko."

Rug Fact: An antique Kurdish rug. Kurdish people are found in northern Iraq, eastern Turkey, and Iran. Like the Kurds, designs are wide-ranging. Their rugs are noted for their consistently strong colors.

Pug Fact: The English playwright David Garrick mocked London women for being so fond of their pugs in his 1740 satire *Lethe*.

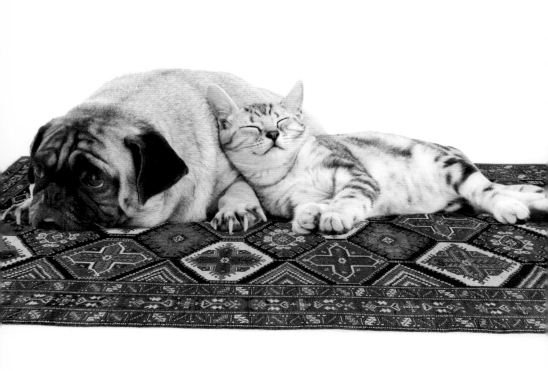

Purrfect Pillow

"Yes, I can see that you're comfortable."

Rug Fact: A geometrically patterned Bakhtiari rug made by nomads in southwestern Iran.

Pug Fact: Alternative names for pugs are Dutch bulldog, Dutch mastiff, mini mastiff, and Carlin.

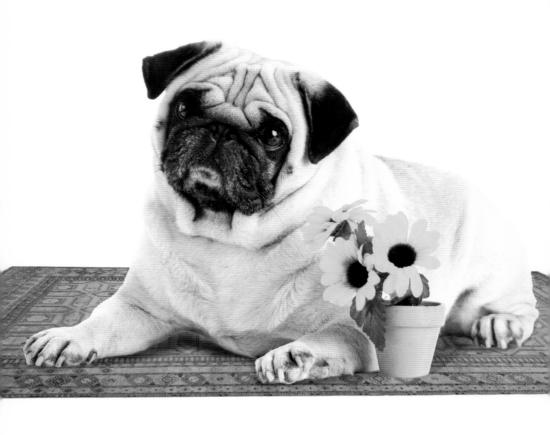

Just Don't Call Me "Petal."

"I admit, I'm not a natural gardener. But I'm Best in Show when it comes to digging."

Rug Fact: An Agra design from India. Agra became a center in rug production in the 16th century when the Mughals made it their capital.

Pug Fact: A pug called Double D Cinoblu's Masterpiece was judged Best in Show out of 2000 entries at the 2004 World Dog Show in Rio de Janeiro.

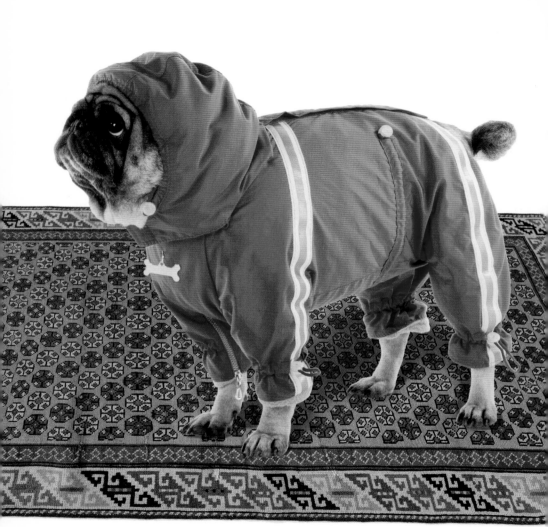

Snug Pug

"As the Swedes say, there's no such thing as bad weather, just bad clothing. I definitely got the clothing."

Rug Fact: A Caucasian Kuba rug. With detailed designs, Kuba rugs have a high knot count and are probably the most tightly woven carpets in the Caucasus region.

Pug Fact: Pugs' ears are either rose or button shaped.

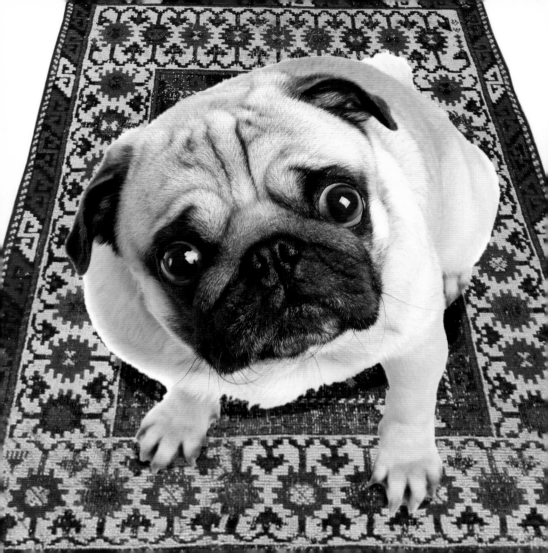

Pug Shot

"I'm afrayed your rug's not safe with this pug."

Rug Fact: An 18th-century Avar rug from Dagestan in the Caucasus region.

Pug Fact: Where does the word "pug" come from? One suggestion is that it's from the Latin word *pugno*, which means "fist," because a pug's face resembles a fist.

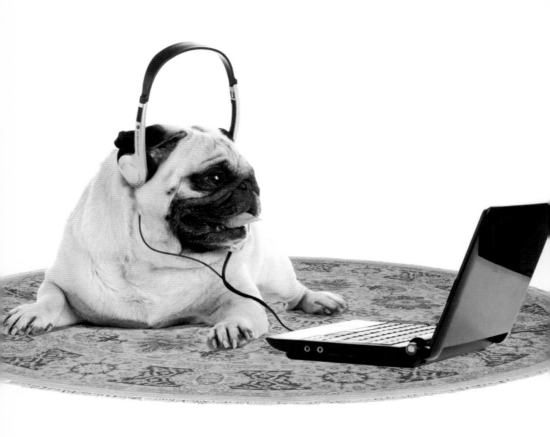

Laptop Dog

"Usually I prefer woofer speakers but, you understand, the neighbors..."

Rug Fact: This is, in fact, a new rug, but it is based on an antique Tabriz style from Pakistan.

Pug Fact: On average, pugs live for 12 years, but a few have lived for as long as 20.

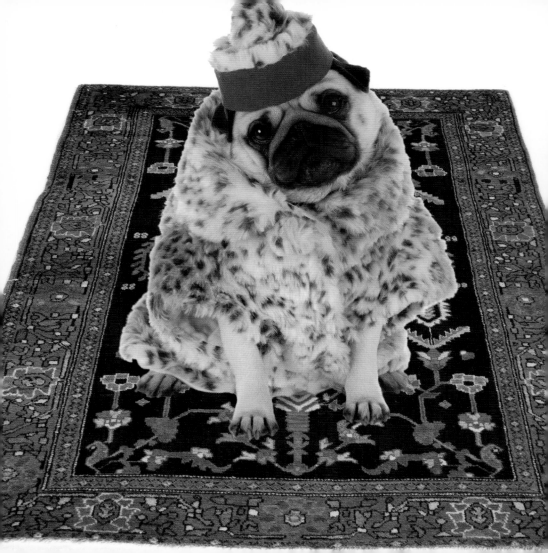

Faux Fur Elise

"If it's any consolation, there's a leopard in Iran modeling pug-fur hats."

Rug Fact: Sarouk rugs from western Iran are made of shiny wool with a Persian knot on a double warp of cotton.

Pug Fact: Some of the most sought-after pugs are porcelain. Pugs produced by the Meissen Factory are worth tens of thousands of dollars.

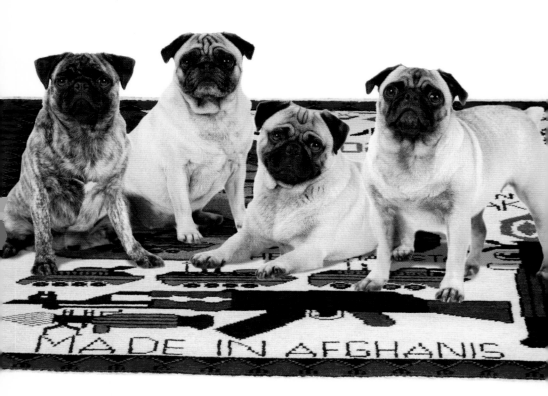

Pugs of War

"Is that what they mean by carpet bombing?"

Rug Fact: Afghan weavers began incorporating war motifs into their rugs during the Soviet occupation (1979–89). At first, motifs such as helicopters were subtly integrated into traditional patterns, while today the subject is quite explicit. Many rugs are made for the export market.

Pug Fact: The English artist William Hogarth included his pug, Trump, in his 1745 self-portrait *The Painter and his Pug*.

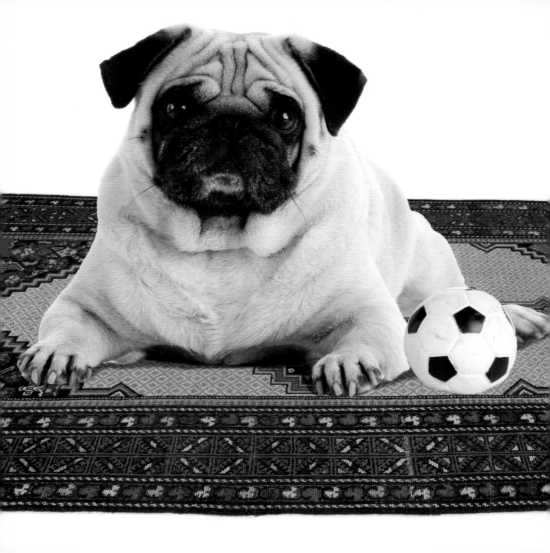

Dogged Defender

"I will only play on heated soccer fields—like rugs."

Rug Fact: Known for their fine long rugs or runners, Persian Serab rugs characteristically have a lozenge-shaped medallion over a camel-colored background.

Pug Fact: Pugs are the largest of the toy dogs, the smallest breeds of dogs.

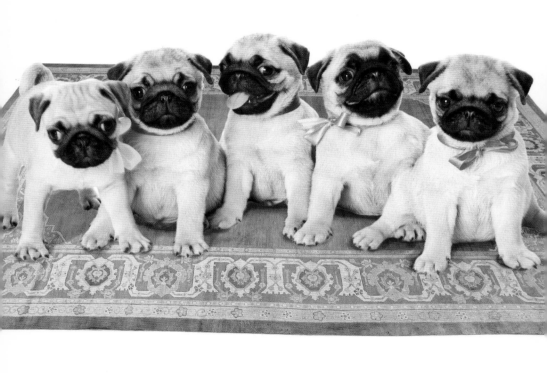

The Usual *Pug*spects

"There's always one who thinks it's clever to put on a silly face."

Rug Fact: A late 19th-century Amritsar rug from northern India, near the Kashmir region. The popularity of this rug grew following demand from British traders.

Pug Fact: If you believe in the collective names for animals— and pugs can be skeptical on this one—the collective name for pugs is a "grumble."

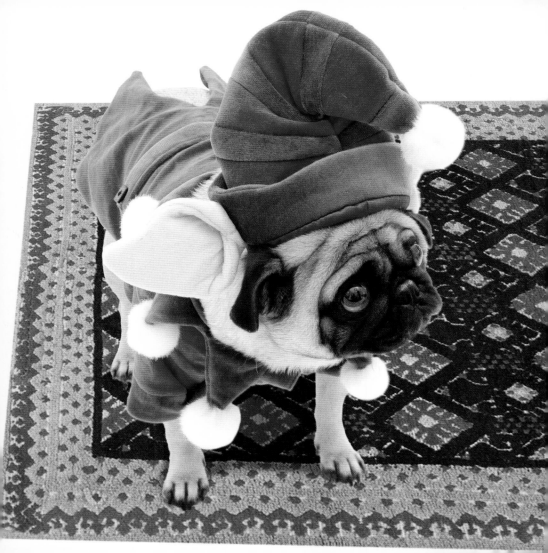

Santa's Little Helper

"If you think I look dumb, you should see the poodle dressed as Santa."

Rug Fact: A Spanish Kerman rug. During the Moors' occupation in the Middle Ages, Spain was the first country in Europe to make knotted pile rugs.

Pug Fact: One theory of how the pug gained its name is that it's a corruption of "Puck," the mischievous elf from English folklore and Shakespeare's *A Midsummer Night's Dream*.

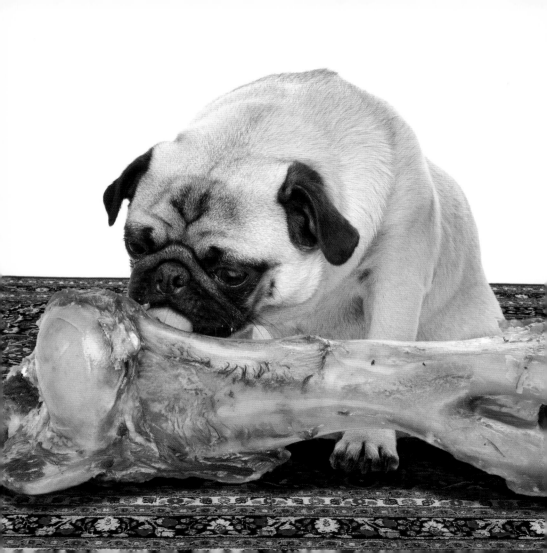

Just Big-Boned

"This is really tasty, but it's huge. I wonder if it shouldn't be extinct."

Rug Fact: Persian Mashad rugs like this are known for their soft wool and medallion patterns.

Pug Fact: In ancient China, pugs were considered hunting dogs, not toy dogs.

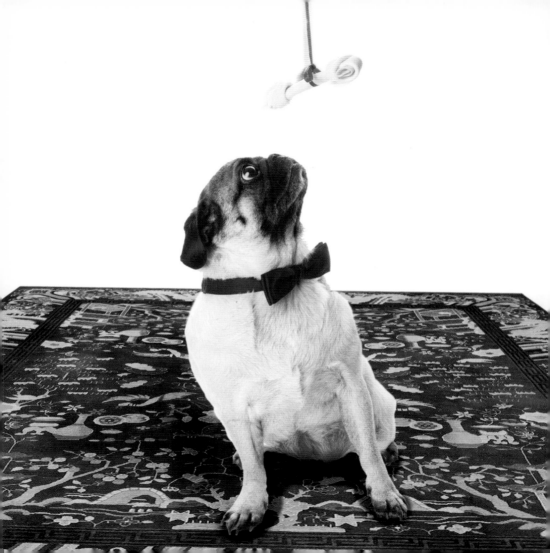

Dressed for Dinner

"I think this tie is a rather well-disguised flea collar, don't you?"

Rug Fact: A Chinese Ningxia rug from the early 20th century with dragons, birds, insects, pottery, and floral motifs.

Pug Fact: Today, we may have guard dogs for humans, but ancient Chinese emperors had human guards to protect the royal pugs.

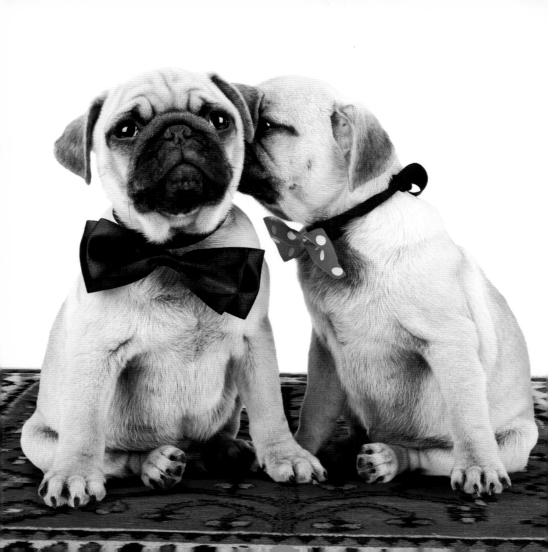

Dog Whispering

"What did the dog say to the dog whisperer?"
"Speak up."

Rug Fact: A Persian Gabbeh rug from the early 20th century depicting a tree of life motif of a pomegranate tree bearing fruit. Gabbehs are much thicker and coarser than other Persian rugs.

Pug Fact: Two of the 20th century's most famous pug lovers were the former king of the United Kingdom, the Duke of Windsor, and his wife, Wallis Simpson.

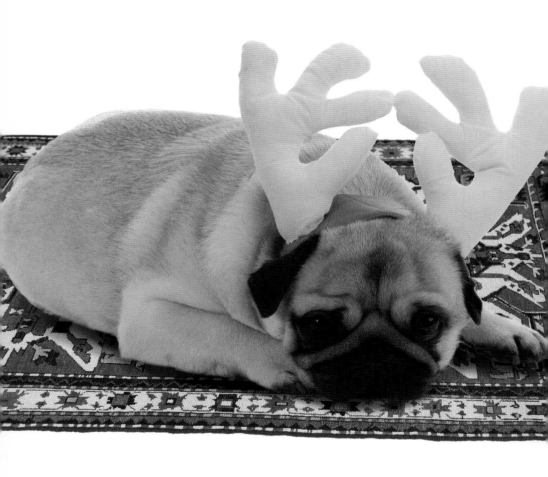

Pug-Nosed Reindeer

"We couldn't find a flying sleigh but we've got high hopes for this carpet."

Rug Fact: An antique Eagle Kazak rug from Armenia. It is believed to owe its pattern to a Christian cross, while the garlands around the border represent sunbursts.

Pug Fact: In the 16th century, wealthy Dutch women kept pugs for their body heat. A pug or two on their laps would help the women stay warm in their large, cold homes.

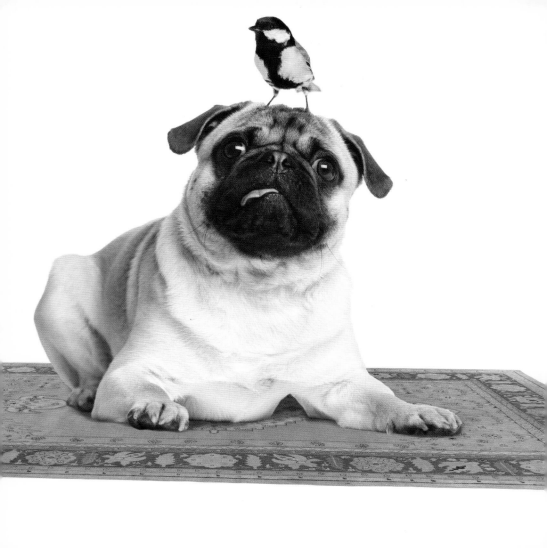

Birdbrained

"You say watch the birdie—what birdie? I can't see any birdie."

Rug Fact: Today, Agra rugs are the most highly sought after of all 19th-century Indian rugs. Because the pile was thicker and longer, they have lasted better.

Pug Fact: When pugs tilt their head and you think it's so cute, they're just trying to hear you better.

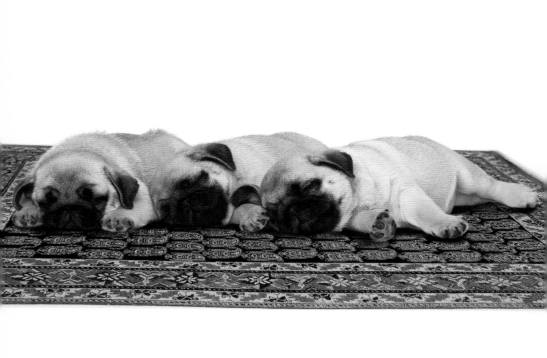

Three Dog Night

Let sleeping pugs lie.

Rug Fact: A Persian Afshar rug. Afshar rugs are known for their rust and blue colors and their geometric designs.

Pug Fact: In 1981, a three-year-old pug won Best in Show at New York's Westminster Kennel Club Dog Show. This is the only time a pug has won the title in a total of 138 years.

THE

END